FOR CRISTINA

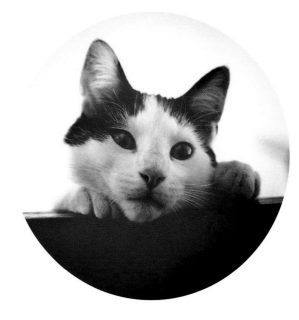

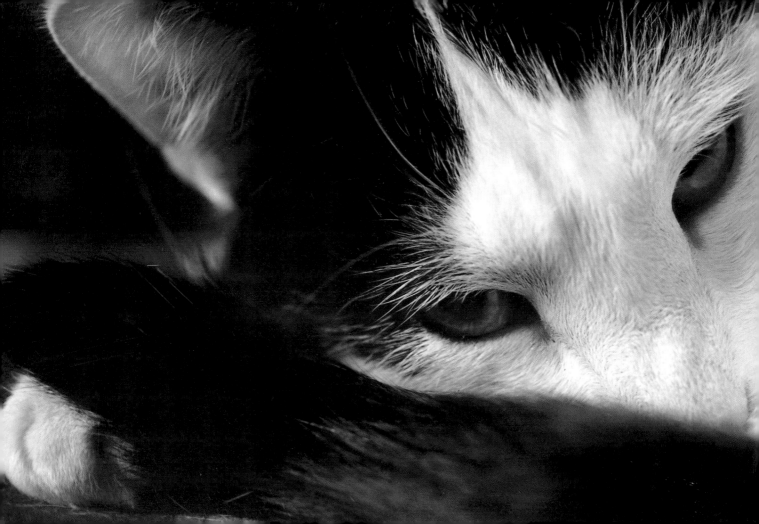

ABC

[CAT]

PHOTOGRAPHS BY **LORENZ KIENZLE**

STEWART, TABORI & CHANG • NEW YORK

Published in 2004 by
Stewart, Tabori & Chang
115 West 18th Street
New York, NY 10011

Canadian Distribution:
Canadian Manda Group
One Atlantic Avenue, Suite 105
Toronto, Ontario M6K 3E7
Canada

ISBN: 1-58479-385-6

10 9 8 7 6 5 4 3 2 1

FIRST PRINTING

Stewart, Tabori & Chang is a subsidiary of

LA MARTINIÈRE
GROUPE

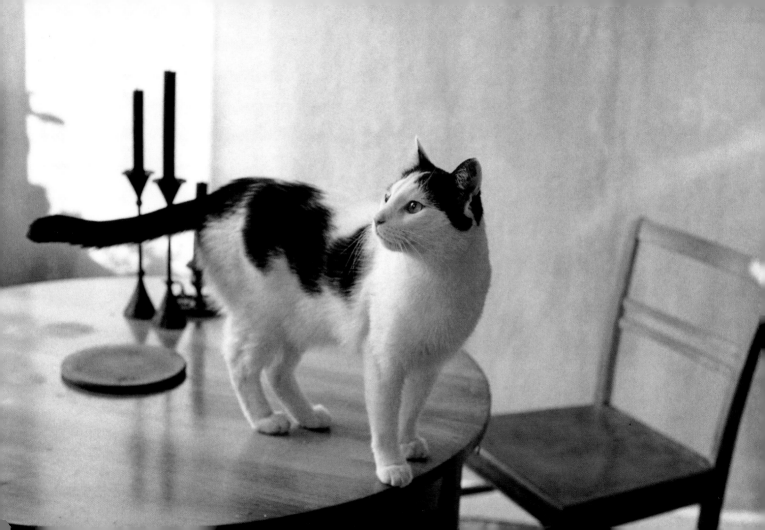

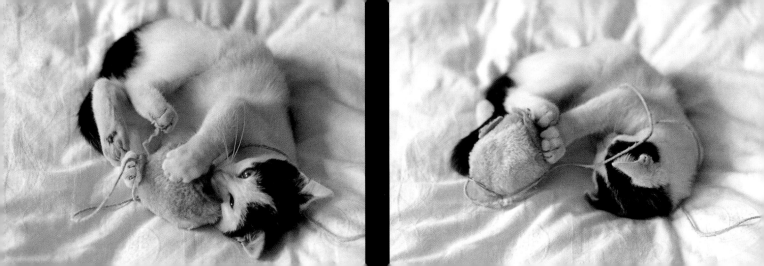

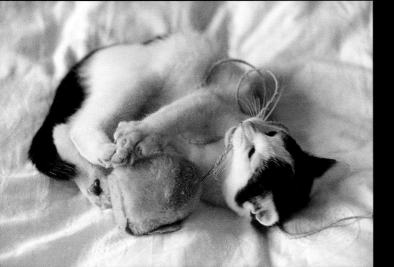

THE ALPHABET

[A C R O B A T]

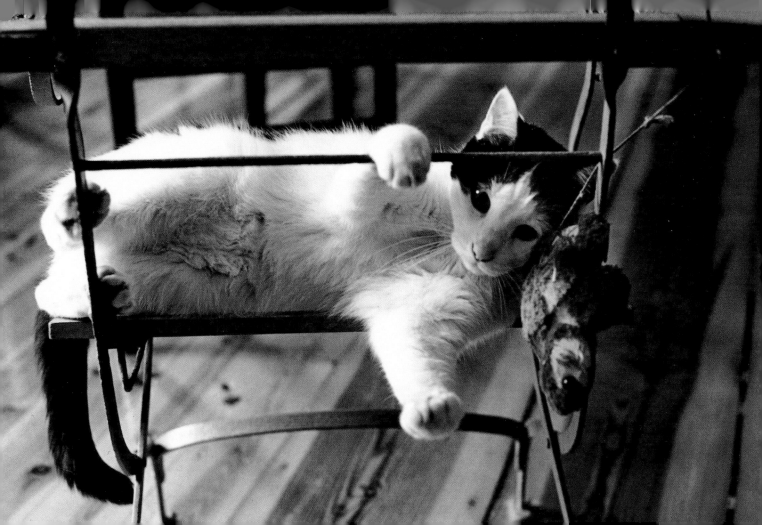

[BUBBLES]

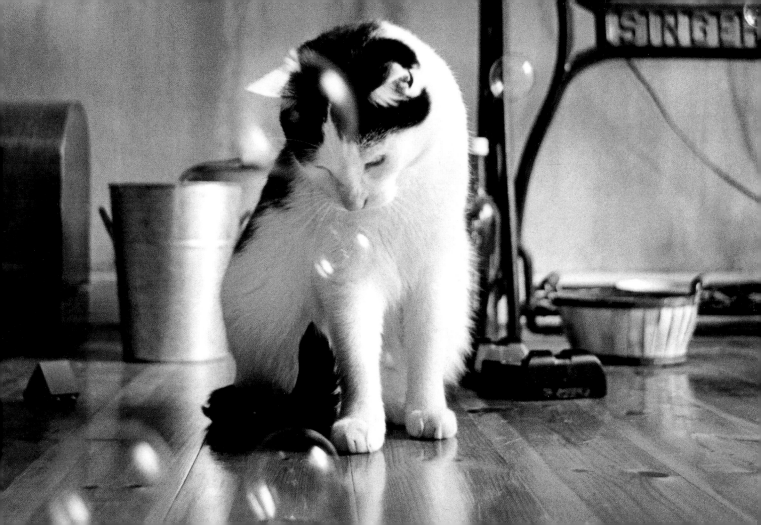

[CUDDLE]

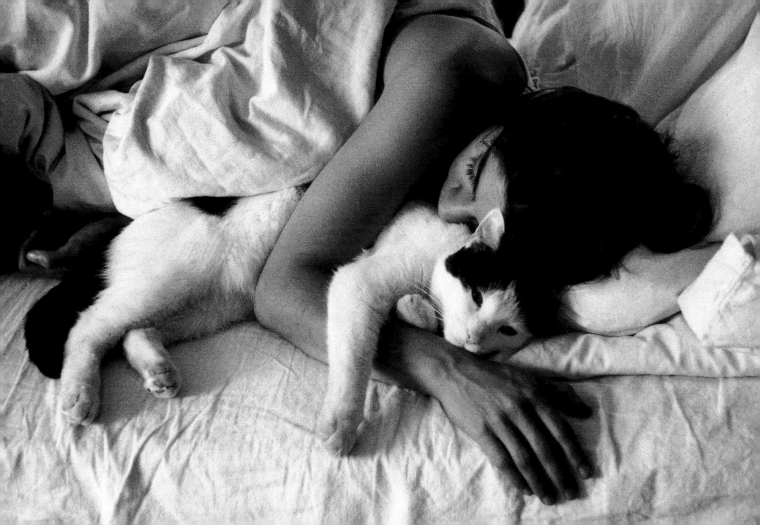

[D R E A M]

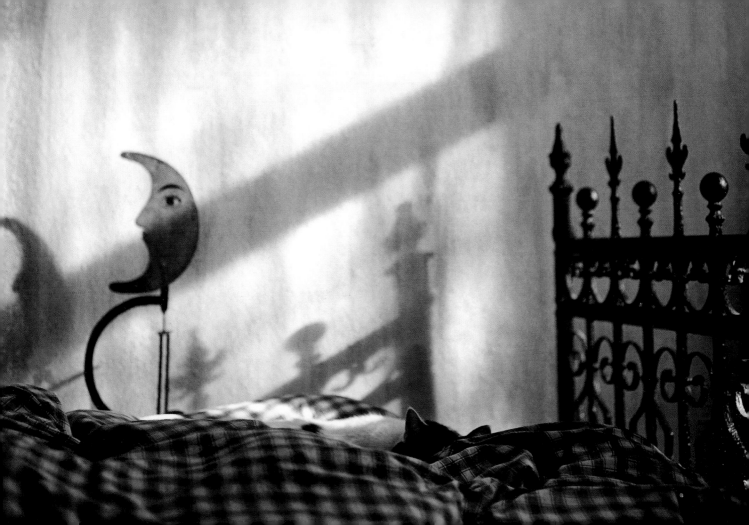

[E D G E]

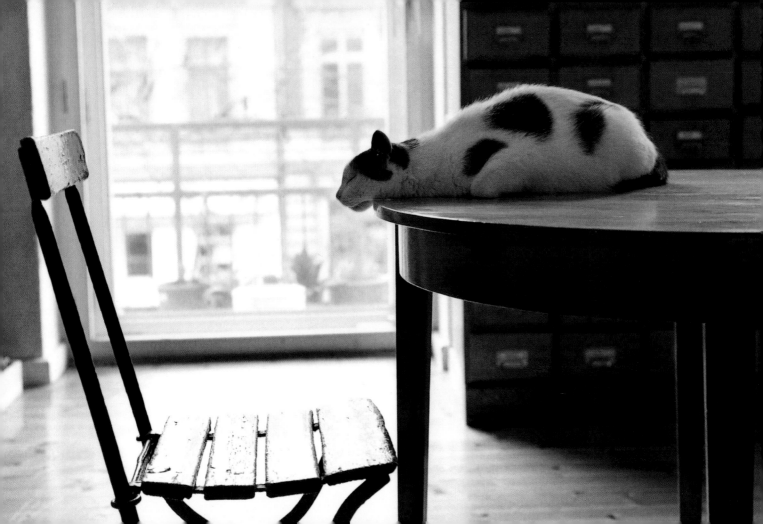

[F L O W E R S]

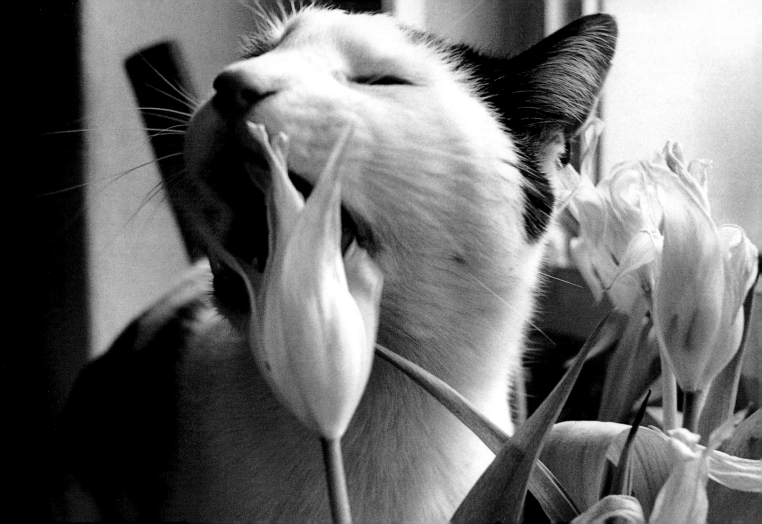

[G R A S P]

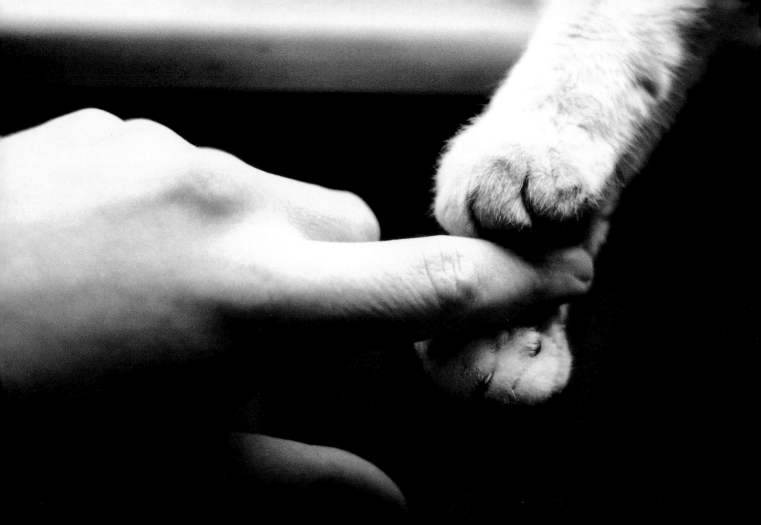

[H I D E - A N D - S E E K]

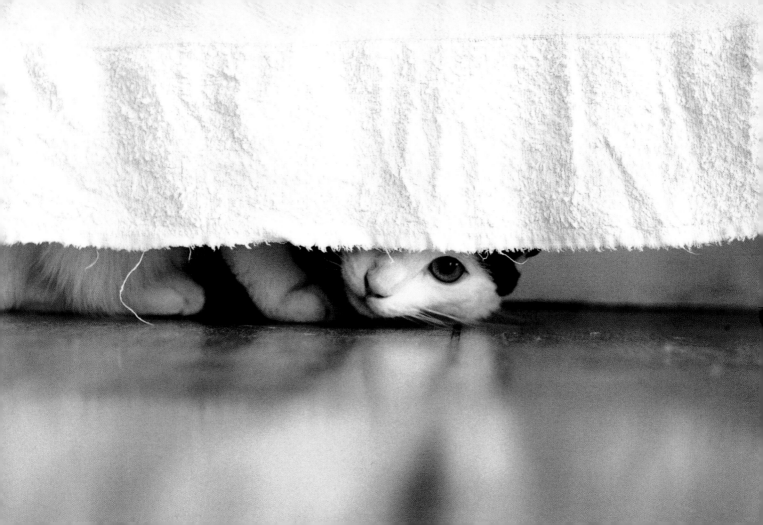

[I N V I S I B L E]

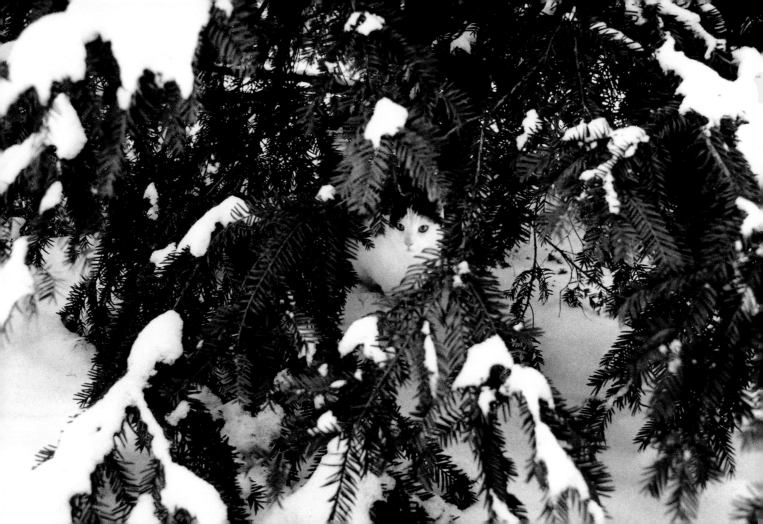

[J U M P]

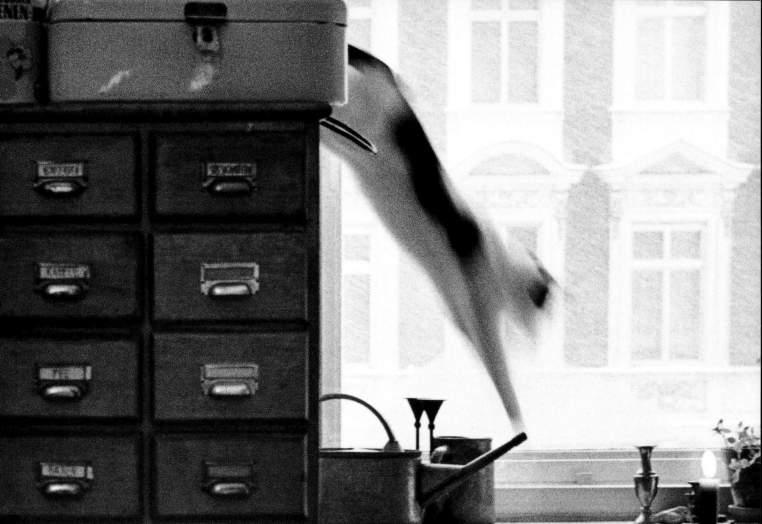

[KISS]

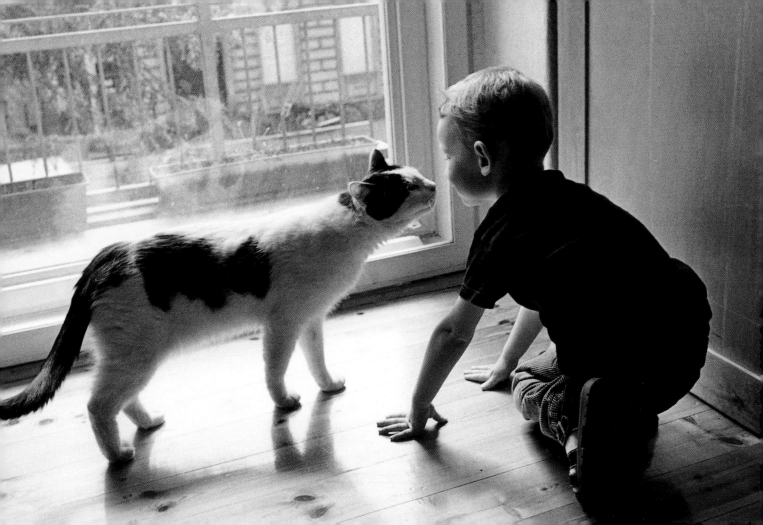

[L E N G T H]

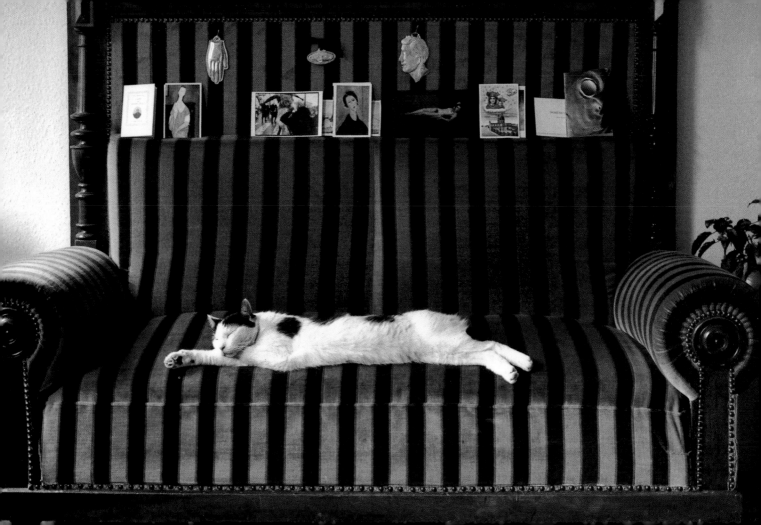

[MOUTH]

[N A P]

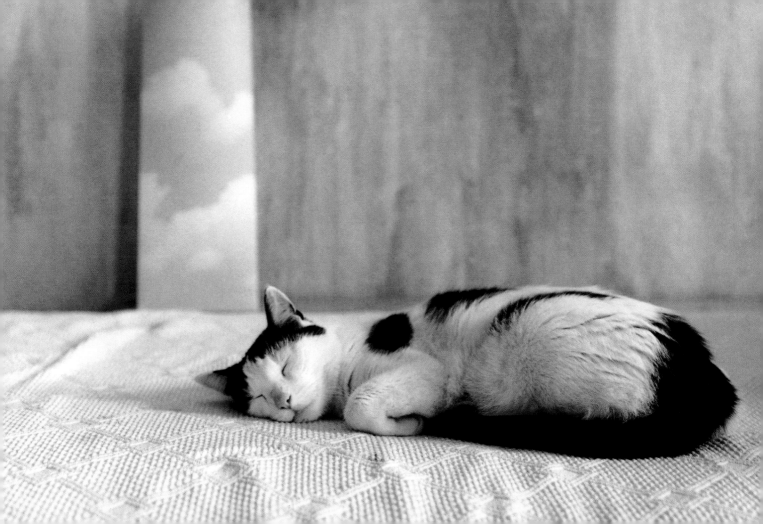

[ONE]

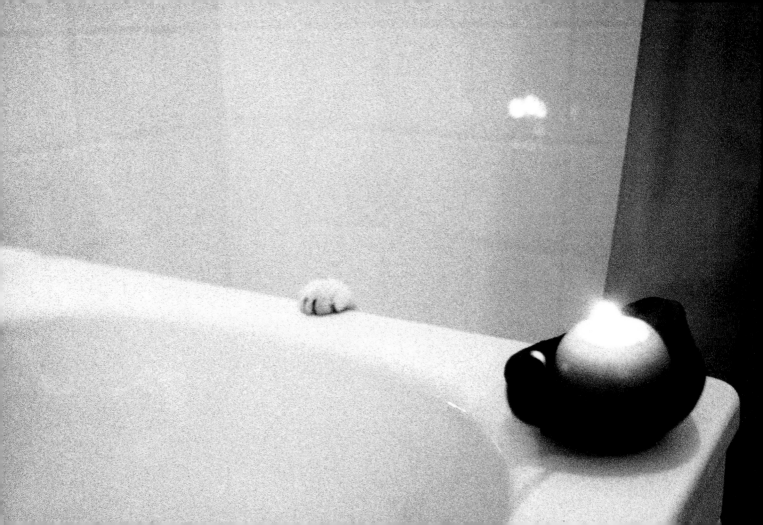

[P E E K]

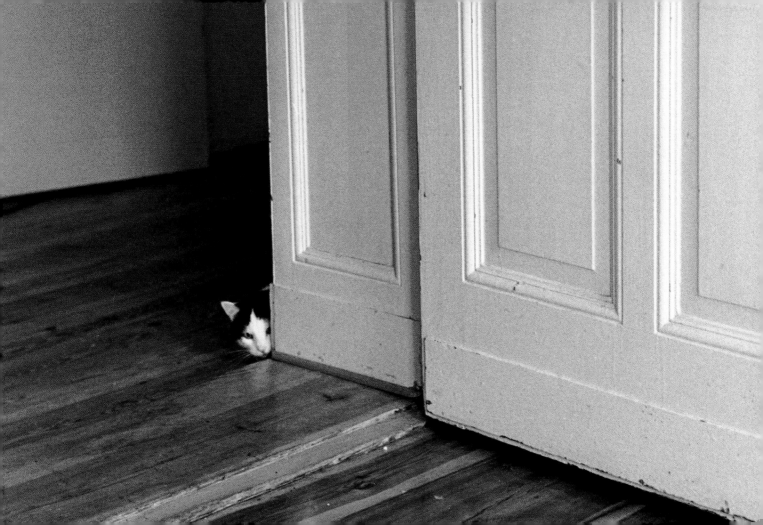

[QUADRUPED]

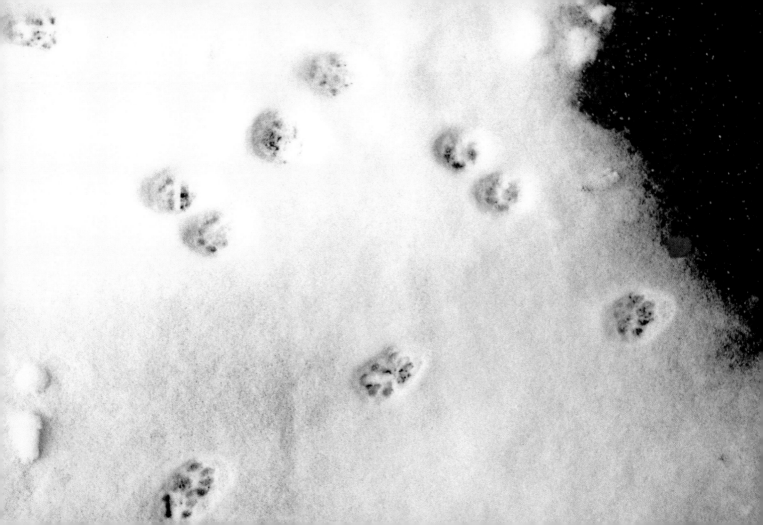

[R O U N D]

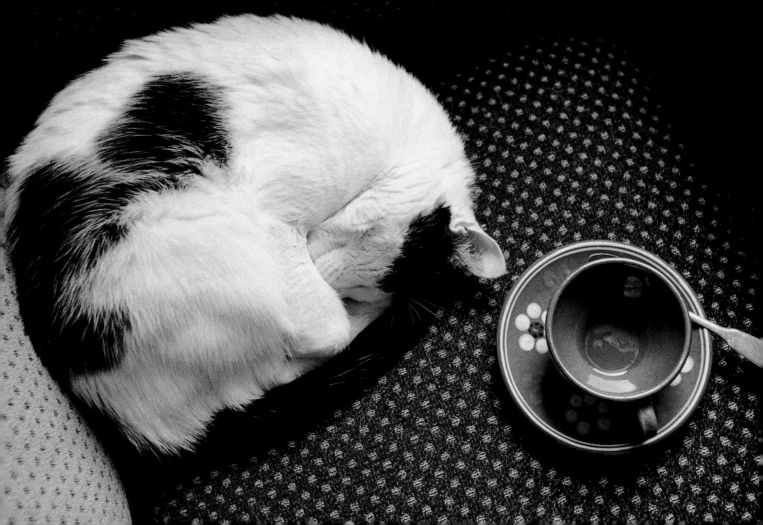

[S T R E T C H]

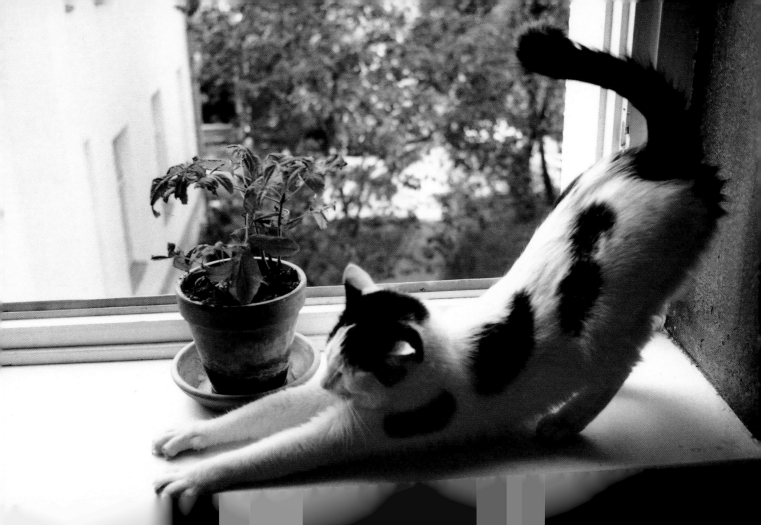

[TAIL]

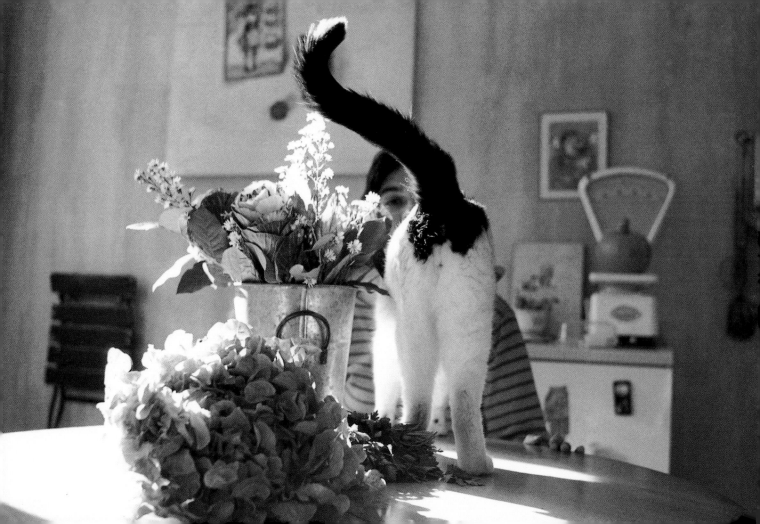

[U F O]

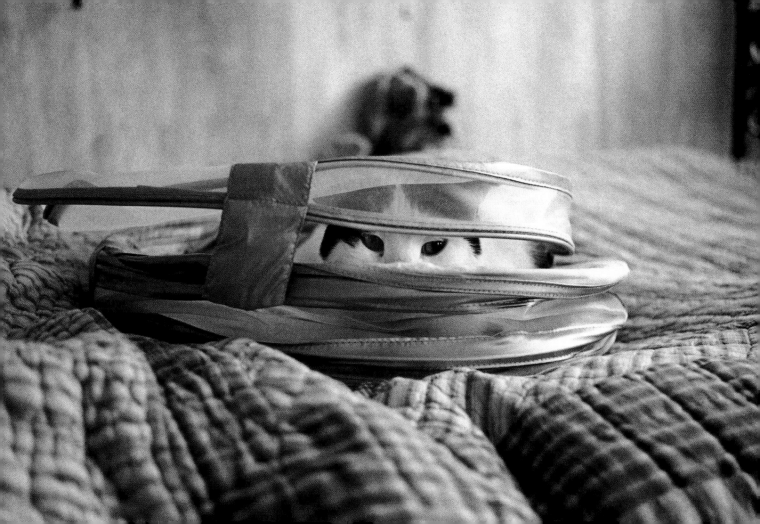

[V I E W]

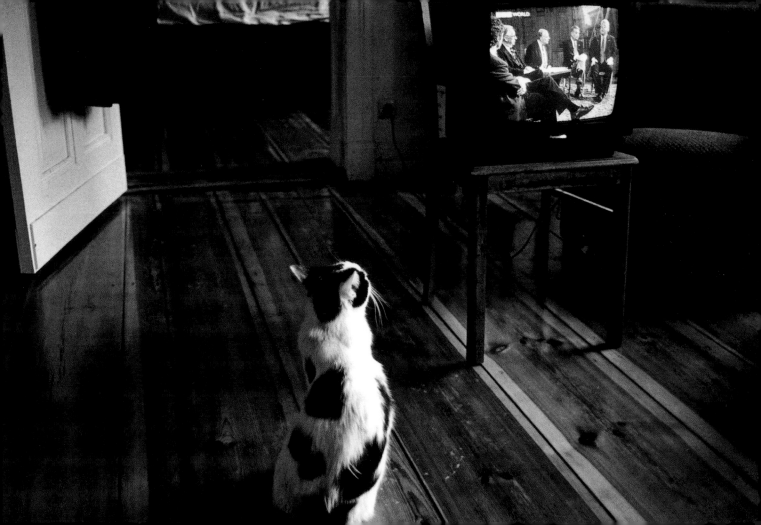

[WATER]

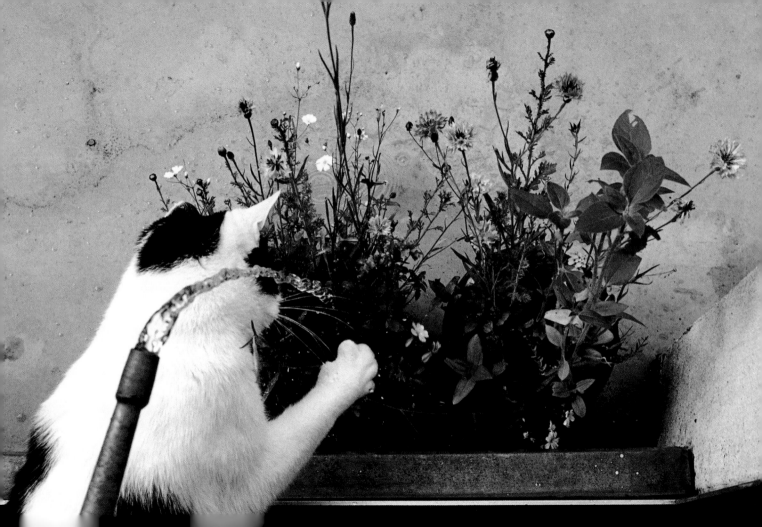

[X E R O X]

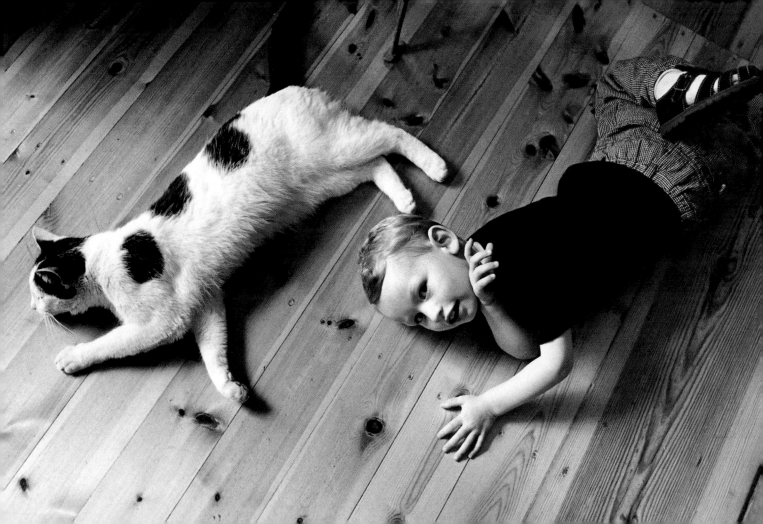

[Y A W N]

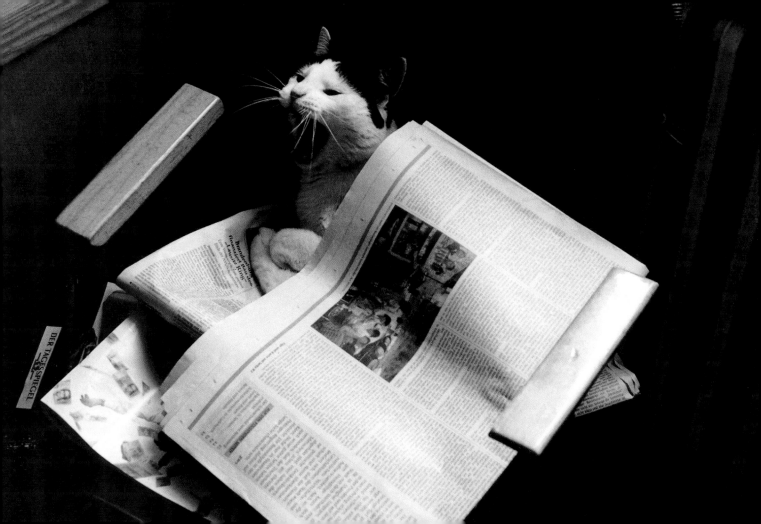

[ZEBRA]

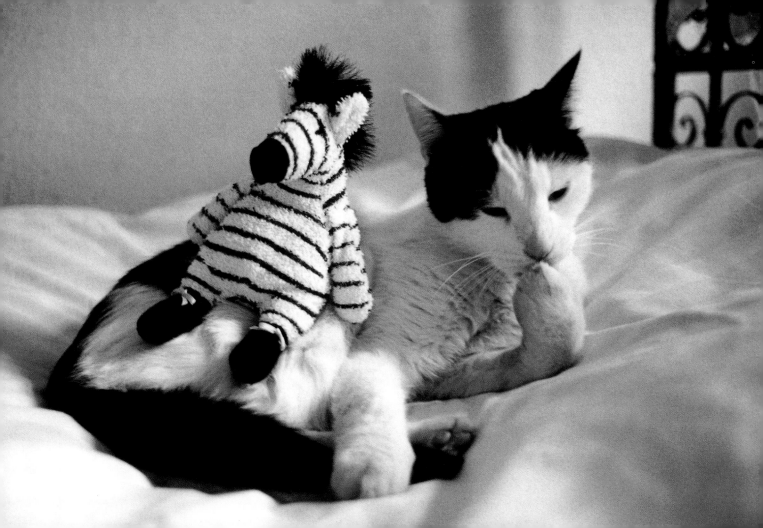

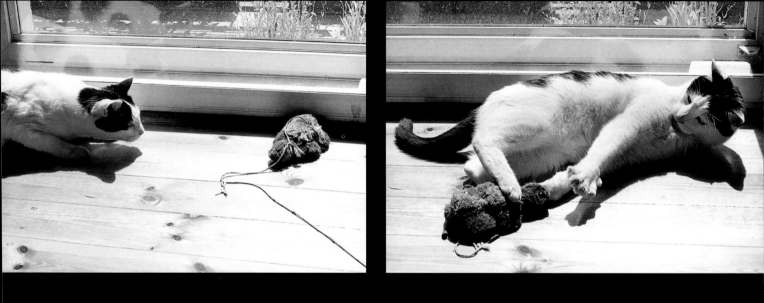

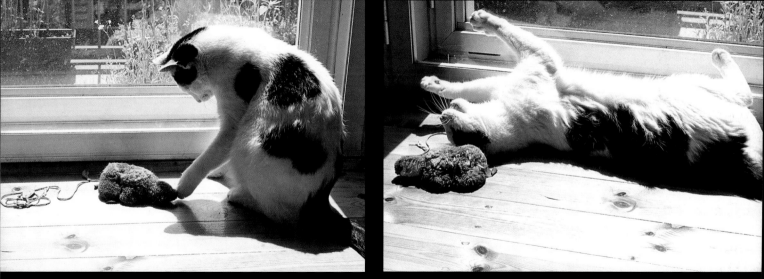

Kater and Lorenz

One day in the summer of 1992, my girlfriend told me that she would like to have a little cat. I wasn't sure this was a good idea and said to her, "A cat is a big responsibility. You have to look after it for its entire life." A few days later I found myself traveling across town carrying a small cardboard box filled with an old sweater, looking for an address given in a newspaper ad for kittens. I arrived at a big house with a garden, many children, a dog, and a large black-and-white cat. The last of the cat's five kittens was staying in a small bathroom, its floor covered with paper. The kitten looked up at me with curiosity and I felt bad that I was going to be separating him from his mother. But he didn't seem to mind and jumped right into my cardboard box. When we arrived back home, I opened the box and said to my girlfriend, "This is a little Kater," which is the German word for a tomcat. The name seemed to suit him and that's what we've called him ever since. Because my girlfriend was traveling a lot, I began to take pictures of Kater—and then put them together to make little stories—so that she would not miss him too much. There is always a camera handy, so I don't miss anything he does. Kater is now thirteen years old, and still as happy and sweet natured as the day we first met. His cat door allows him to go into the garden whenever he wants, and he comes back through it bringing mice and lots of dirt into the apartment. So he may not be a big help with the housework, but he is the most precious little being I have ever had.

LORENZ

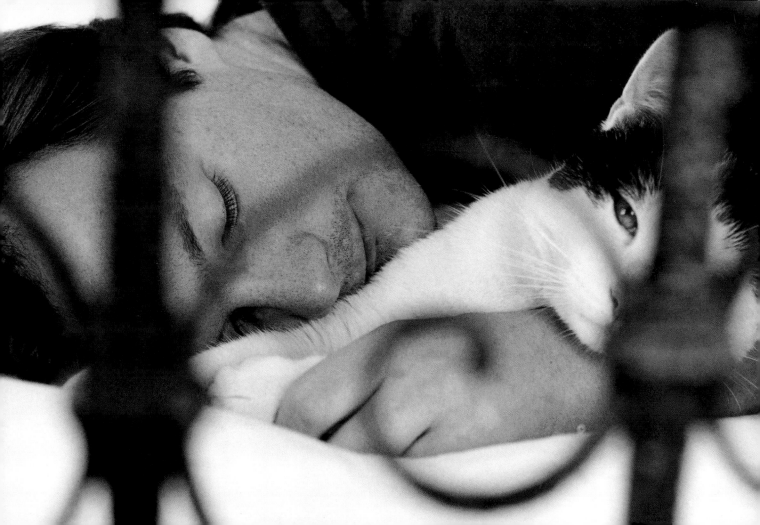

LORENZ KIENZLE is a photojournalist who lives in Berlin, Germany. His work has been exhibited in galleries and museums in England, France, Italy, and Germany.

Photo of Kater and Lorenz by Cristina Piza.

The text of this book was composed in Bernhard Gothic and Premier Lightline.

Edited by Marisa Bulzone • Graphic Production by Alexis Mentor • Design by Susi Oberhelman • Printed in China by C&C Offset Printing Co., Ltd.